Degas and His Model

David Zwirner Books

ekphrasis

Degas and His Model
Alice Michel

Translated by Jeff Nagy

Contents

A Model's Agency

Jeff Nagy

Chrissakes, Pauline! No one would have been more horrified than Edgar Degas at the thought of a model taking up the pen. Not a fan of working-class literacy in general, he might well have died of apoplexy at the very idea that a model might dare not only to write about art, but about his art. And from the very first words, we know that Alice Michel's memoir is not going to be a typical hagiography of a great dead artist. This Degas is not the elegant gentleman, proud member of the Parisian haute bourgeoisie and scion of a well-to-do and diasporic family, with branches running banks in Naples and plantations in New Orleans. Nor is he the grand habitué of ballets, café concerts, and the opera, haunting the loges alongside his one-time friend librettist Ludovic Halévy. Not the cultivated disciple of Mallarmé who tried his hand at the occasional sonnet, not the obsessive aesthete who co-organized the exhibitions that made Impressionism an art world phenomenon, and certainly not the purveyor of cutting, perfectly formed witticisms at exhibitions and dinner parties.

When the *Mercure de France* published the two installments of *Degas and His Model* in February of 1919, the artist's legacy was nearing apotheosis. Begun early the previous year, the ongoing auctions of his atelier and private collection had already set new records. Bidders braved active German bombing campaigns to crowd into the Galerie Georges Petit on rue de Sèze in the hopes of taking home a pastel dancer or two of their own. The international press lavished attention on the sales, which were

even reported in wartime Germany after a sympathetic Swiss citizen offered himself as a stringer. Back in Paris, *Le Figaro* devoted columns to Degas's genius alongside long lists of works sold and the eye-watering prices they'd fetched, prices that even Degas's dealer, Paul Durand-Ruel, thought perfectly insane. At the same time, colleagues and friends of the artist published dozens of eulogies, remembrances, and collections of anecdotes testifying to his artistic inventiveness and indefatigable drive. Paul Lafond's 1918 two-volume *Degas*, the first book-length monograph, is a typical case, presenting the artist as simultaneously a totally unprecedented, original genius and the logical conclusion and summation of French painting going back to Poussin.

In contrast, Michel's Degas is an almost systematic inversion of the reverent testimonials current in the French press in the years after the artist's death in 1917. Degas as seen by the model Pauline is no stoic devotee of the Muses, but a curmudgeon subject to sudden bouts of theatrical self-pity, always on the verge of collapsing into melancholy ruminations over his failing sight, his oncoming death. The artist famous for his deft public quips becomes, in private, a mealymouthed, repetitious prattler, retailing twenty-year-old anecdotes for the two-hundredth time. Instead of zingers (e.g., Gustave Moreau is "a hermit who knows what time the trains leave"[1]), the model is obliged to de-escalate incoherent rants about Jewish conspiracies and feign interest in foggy reminiscences of trips to Italy and bouts of pubic

lice. This Degas is not only tedious company but a volatile and occasionally violent taskmaster, liable to punch Pauline in the back or threaten her with a hammer when the session isn't going as well as the artist would like, and perfectly capable of firing her for reading a book or—virulently anti-Semitic as he was—posing for a Jew. But perhaps the most cutting feature of Michel's portrait is that "old Father Degas" is artistically impotent. He can finish nothing, and statuettes that represent years of work over hundreds of sessions crumble to dust before his eyes, to be begun again, and again, in a cycle broken only by his death. Instead of a prolific visionary, Michel's Degas more resembles a Beckett character retrofitted for Third Republic melodrama.

*

* *

Who was Alice Michel, and who was the model who provided the evidence for this thoroughly demystified version of Degas? There is no other record of a woman by that name writing for the *Mercure de France*, which, in any case, very rarely published women at the time. Nor is there a trace of her in any of the other contemporary French newspapers and literary journals, and her name isn't to be found in the archives of the Bibliothèque nationale de France. While there are presumably documents in the journal's own archives that would allow one to follow the manuscript's receipt, editing, and publication,

including payment made to someone with an ascertain-able identity, those records are privately held and closed to the public. As for Pauline, three models by that name are listed in a handful of pages in one of Degas's note-books, where he was in the habit of jotting down models' addresses: Pauline Fournier, Pauline Lansart, and Pauline Friese, three candidates for the source of *Degas and His Model*. But Degas used the notebooks haphazardly over the course of his career, making individual entries impos-sible to date, so there is no way to know when any of these three models posed for him, nor whether one of them did so in December of 1910, when Michel's Pauline claims to have posed for a version of the sculpture *Dancer Looking at the Sole of Her Right Foot*.

The handful of art historians and curators who have drawn on Michel's text to establish chronologies for spe-cific sculptures, or for information about Degas's late studio practice, otherwise sparsely documented, have typically assumed that the text is authentic. The editors of the 2012 French edition issued by L'Échoppe, which is the source for this translation, come to similar conclu-sions, asserting that Michel and Pauline are pseudonyms for the same individual, a model relating her firsthand experience. But there are certainly reasons to suspect that the real nature of the text is not so straightforward. In its original publication in the *Mercure de France*, it was presented without commentary, and no explicit claims were made for its authenticity. Nowhere does Michel state that she is Pauline or that the events she uses Pauline to

narrate constitute a "firsthand view." The model herself remains a cipher: we learn nearly nothing of her family life, of how she came to modeling, of what she does when she's not posing. She serves instead to establish a perspectival framework that allows Michel to string together anecdotes about Degas, a format typical of accounts of artists' lives in the period. And those anecdotes often seem carefully considered to hit on aspects of his personality that were, to some degree, commonly known—his political conservatism, his gruff manner—as if Michel were making an effort to hew just closely enough to testimonials by individuals known to have been intimate with the artist. Finally, the decision to begin Pauline's account in medias res, with Degas's light curse almost a distant echo of Alfred Jarry's famous "Pschitt," is certainly a literary touch. If Pauline is not necessarily Michel and vice versa, who could have been behind all this? An unknown individual capitalizing on the spate of interest in Degas? An associate of the recently deceased artist, male or female, writing under the cover of a pseudonym to slightly deflate his skyrocketing posthumous reputation? A journalist working from interviews with a model or models to produce a synoptic account?

Are the intricate descriptions of the artist's studio and apartment sufficient evidence to demonstrate a kernel of authenticity somewhere in the text's nested pseudonyms? Despite the artist's notorious reclusiveness, previously published memoirs revealed at least some of this supposedly intimate information. But Michel provides one detail

that might inspire confidence, precisely because of its seeming inconsequence: Pauline reports two sessions in the course of which Degas drinks an infusion of cherry bark tea prepared for him by his maid, to ease a bladder disorder that forces him to get out of bed a half-dozen times a night to urinate. It's a microscopic detail that Vollard, in his own subsequently published book on the artist, also mentions: "He was walking about with a bowl of cherry bark tea in his hand and suddenly he looked up absently and said: 'Do you have trouble urinating? I do, and so does my friend Z.'" [2] Homeopathic infusions and troublesome nocturia were not, as might be expected, common features of testimonials about Degas.

My own belief, which I cannot prove, is that Pauline was indeed a professional model who worked for Degas, as Michel presented her, but that Michel herself was a pseudonym adopted by Rachilde, the pioneering decadent novelist who cofounded and edited the *Mercure de France* with her husband, Alfred Vallette.[3] Traveling in progressive and protofeminist circles in early twentieth-century Paris, and occupying a significant position in an overwhelmingly male industry, Rachilde would likely have been sensitive to issues of women's labor. Perhaps just as importantly, she had the institutional power to see that such an extremely unusual document found its way into print.

*

* *

Whoever Michel was, she left us, if not a first-, then at least a secondhand view not only on Degas's late work but on the work of the model herself.[4] As interviews with models published by turn-of-the-century journalists like Alfred Dollfus and Marie Laparcerie demonstrate, no matter where you posed, the work was guaranteed to be precarious: the winter high season alternated with months of unemployment when commissions fell off and artists left Paris for their country homes. It was also relatively stigmatized: Dollfus, for instance, often seems to suggest there's only the thinnest line between modeling and unregulated prostitution. But if you posed for Degas, conditions were perhaps notably worse. He paid poorly, at a rate of five francs a session, the same amount a model working two decades earlier could have expected. The atelier was cold and perpetually filthy, and, perversely for a man who spent so much of his life depicting bathing women, models were not permitted to wash themselves. And Degas had a mania for strenuous poses that left the women who assumed them cramped and numb. But since he often hired models for four or five sessions a week, the one thing that could be said for it was that it was regular.

Michel's account also makes clear just how much of Pauline's energy went into the affective labor of managing Degas's mood swings, a delicate task that required her to show interest in the artist without him becoming suspicious that she might be having anything like an idea of her own. "Now there are even *models* who come around

wanting to talk to you about art, painting, literature, as if it were enough simply to know how to read and write to really understand anything." The slightest hint of working-class intelligence makes him rant until he drools. Pauline holds her tongue, knowing that any objection will get her fired on the spot. She held it for almost a decade, until Alice Michel helped her have her say.

1 This bon mot is ubiquitous in remembrances of Degas's conversation. One early source is in Paul Lafond, *Degas*, 2 vols. (Paris: H. Floury, 1918–1919), p. 150.

2 Ambroise Vollard, *Degas: An Intimate Portrait*, trans. Randolph T. Weaver (New York: Crown Publishers, 1937), pp. 86–87. The original French edition, *Degas (1834–1917)*, was published by G. Crès et Cie in 1924.

3 Heather Dawkins, one of the very few art historians to pay any attention to *Degas and His Model*, was the first to raise this possibility in her book, *The Nude in French Art and Culture, 1870–1910* (Cambridge: Cambridge University Press, 2002). I am indebted to her careful scholarship for many of the considerations in this introduction.

4 For an excellent study of the transformation of the labor of modeling in the mid-nineteenth century, see Susan Waller, *The Invention of the Model: Artists and Models in Paris, 1830–1870* (Aldershot: Ashgate, 2006).

This text first appeared in two successive issues of the *Mercure de France*, on February 1 and 16 of 1919, eighteen months after Degas's death in September 1917 and during the course of eight auctions of the artist's atelier and private collection between March 1918 and July 1919. Nothing is known about its purported author, not even whether Alice Michel is her real name or a pseudonym. Did she write it alone? Did she work in collaboration with someone else? Whatever the case may be, the text is a uniquely valuable document: a firsthand view of Degas at work in his studio in his final productive years at the beginning of the twentieth century. The model, Pauline, is clearly a stand-in for the author, a tactic that enables her to avoid having to write in the first person. She tells her story in unflinching detail, and nothing about the great artist is hidden from us: his single-minded nature, his fantastical miserliness, his gruff manner of speech, his occasional generosity. Not to mention his anti-Semitism, which became so virulent over the course of the Dreyfus affair that he broke off contact with his old friends the Halévys. Through the eyes of a young model we see Degas between the ages of sixty-five and seventy-five. A solitary artist, whose primary desire was to work every day without cease in spite of his progressive blindness. A solitary artist who nevertheless hunted through all of Paris in search of works of art for his private collection. An artist who in part abandoned painting to concentrate on sculpture and, like Giacometti a half century later, was never fully satisfied with the results, returning again and again to his unfinished work.

This introductory note was written by Patrice Cotensin for the 2012 French edition published by L'Échoppe.

Degas and His Model

"Chrissakes, Pauline!" Degas shouted to his model, marking his words with an emphatic thump on the stool. "You're posing miserably today! If you're tired, just say so."

"I'm tired," she confessed. It'd been a long fifteen minutes. Pauline was exhausted from the tension of balancing on her left leg while with her right hand she struggled to grasp her right foot and lift it up behind her.

"Fine, so rest. And then try to get the movement right."

Sullen, the young girl slid her bare feet into a pair of slippers waiting on the ground next to the modeling platform. Without a word, she climbed down and hurried across the room to the stove. Her leg had gone numb from holding the excruciating pose. As she rubbed it back to life, she snuck the occasional annoyed glance at the old artist, still shaping and reshaping his clay statuette.

What was wrong with him today? He'd grumbled at her all morning: "You can hold it better than that!" "Lift your foot higher!" "Straighten your torso!" "Don't slouch!" Couldn't he see she was doing her best? And he was usually such a chatterbox. Why wasn't he talking? Every time she tried to start a conversation he responded in monosyllabic grunts. And then he'd bawled out his poor old maid [1] so harshly she'd finally broken down in tears, just because he thought she hadn't lit the fire properly.

She continued to watch Degas, who was peering at his figurine so closely that his long white hair brushed against it. He looked like an ogre: his prominent forehead bulged over his nose, and when his nostrils flared you thought he might even breathe fire! The large mouth was

obstinately closed, but beneath his short white beard, always a bit patchy, you could make out a stubborn chin.

Degas stood up suddenly, almost overturning his chair. It was the kind of brusque movement she'd come to expect. He stalked off with quick steps into the little side room, his head thrown back almost behind his stiff body, the long gray smock flapping behind him. Pauline took advantage of his momentary absence to scurry over and check her watch, which she'd left on an easel behind the folding screen. It was only 11:30—still a long half hour to go with this moody old buzzard!

The girl walked slowly back to the little stove. Her eyes drifted across the atelier, taking it in with profound boredom. The room was enormous but dark. The high north-facing windows that spanned an entire wall were nearly blocked by a canvas curtain, stretching from the ceiling to just above the floor. A dull daylight struggled to reach the back of the studio, and even this was intercepted here by an armoire, there by dozens of easels jumbled together on top of each other, or by sculptor's seats, tables, chairs, stools, a number of screens, and even a bathtub for posing a model as some *baigneuse*. The corners were no less cluttered: mountains of frames were stowed next to empty stretchers and rolls of paper. All this left Degas a quite limited space to work in, near the front of the atelier, just below the windows. It was there that Pauline spent her mornings, on the modeling table surrounded by a folding screen, between the sculptor's stool and the stove.

In Pauline's opinion the most unpleasant thing about the atelier was the dust that lay thick on every last piece of furniture. Poor old Zoé was only allowed to light the stove, sweep around it and the stool, and along the path that led to the exit door in the middle of the atelier. Anything else was forbidden: Degas categorically refused her permission to clean even a bit of the filth that had built up year after year. Maybe he tacitly feared some clumsy blunder on her part, but he swore up and down that sweeping only moved dust from one place to another, ruining frames and canvases in the process. His models begged Zoé to at least clean the little bench behind the screen, where they left their clothes and belongings during the sessions. But their pleas fell on deaf ears: Zoé dared not give in to them and disobey her master's commandment.

There was nothing to cheer up this somber room, not the smallest trinket or even a cheap drapery. The doors and the high brown walls were bare, without a single drawing or painting. Degas stored all of his works away in boxes and armoires or else piled them in the little room at the back of the atelier. The sole exception was a large canvas of almost two meters by one and a half on an easel near the models' bench. It showed a group of dancers on a stage, turning under the harsh light of electric lamps. The large, luminous foyer, the brightly colored costumes, the garish makeup on the dancers' faces—splashes of white, red, green, and violet that despite the general gloom were visible even from the atelier's door. From her

very first session, Pauline had always seen the painting in this exact spot. She wondered what could be behind this exception to his otherwise unbroken rule against decoration.

The model quickly tired of studying the furniture, the walls, the dirty flooring. She could think of nothing but warming herself somehow in the frigid room, and she opened and closed the stove door in the hopes of drawing the aging artist's attention to the fire, which was beginning to sputter. He roared at her to leave it alone.

After he'd finally condescended to add a shovelful or two of coal, Degas collapsed in his chair, backed against the wall next to the window. He sat there without moving, his legs crossed and a hand over his eyes, seemingly deep in thought.

A few minutes passed in absolute silence, finally broken when he leapt from the chair and settled in front of the statuette. Pauline climbed onto the modeling platform and assumed the pose.

Standing on her left leg with her knee slightly bent, she lifted her other foot behind her with a vigorous movement and grasped her toes with the right hand. She turned her head until she could see the sole of her right foot, raising her left elbow high to keep her balance. Every last one of her muscles was tensed. She managed to hold the pose for an entire minute before her left leg began to wobble and she had to break out of it to keep herself from falling. Leaning a hand on the screen, she rested a moment or two before attempting the movement

again, until, again, the leg shook and she had to let the other foot drop.

While she posed, Degas, his eyes nearly closed behind his glasses, examined the contours of her naked body, comparing them to his statuette. But even though he was seated inches from Pauline, he could only vaguely make out her form. He stood up again and again to run his hand along the line of her thigh or to check the position of a joint, while the thumb of his opposite hand shaped the clay accordingly.

The model posed and rested, posed and rested with no further commentary from Degas. She had begun to think that perhaps his mood had softened when he brought a fist down on her back so hard that she nearly fell.

"Your posing is so terrible you'll make me die of apoplexy," he said, wheezing.

"Monsieur Degas," she primly replied, "no one but you has ever found my work lacking."

For a long minute, Pauline and the artist stared with rage into each other's eyes, each of them just as furious as the other. Degas grit his teeth. Then, with a glance at the face of his large nickel watch, he relented and almost begged her:

"Just pose properly for five minutes so I can take some measurements. Then I'll let you go for the day."

Pauline pouted. She knew what was coming: he wanted to use the compass, an instrument he handled ineptly at best, jerking it back and forth over his poor models' bodies. It was a miracle he'd never put anyone's

eye out with it! And then there were the scrapes and scratches its points dug across you. No matter how nimbly the models tried to avoid them, they weren't always lucky enough to escape the session unharmed, and more than one had left the atelier with a red slash running the length of an arm or a leg.

Her guard was up when she saw Degas approach holding the large reduction compass, after he'd calibrated the distance of its points against a guide chalked onto the wall nearby. This time, at least, her fears were unwarranted. She wasn't harmed, but a compass point caught in one of the buttonholes of the old artist's smock and the instrument swung open wide. Railing against "these idiotic outfits," Degas tore the smock from his chest and hurled it onto the couch. He began the process again. Pauline followed him closely with her eyes, holding her breath until the measurements were complete.

"Go on then," he said at last.

She dashed behind the screen at once. The clothes she'd left on the bench were ice-cold, and she silently cursed this fusty madman for making his models dress and undress in a dark, dirty, freezing corner of the atelier instead of letting them do it near the stove like anyone else would. Her temper went from bad to worse when she saw that her skirt had fallen behind the bench and was now covered in dust.

There was no point asking for a brush: Degas would never admit it was possible for someone to dirty themselves in his atelier. One day she'd asked to wash her

hands, black with filth, and he'd rebuked her sternly, saying it was a ridiculous affectation to be always splashing about in bowls of water.

Pauline almost wanted to cry when she remembered that tomorrow and even the day after she'd have to spend yet another interminable, exhausting morning with this cranky and demanding old buzzard. She would have loved to drop Degas and his statuette for good. But artists who would hire you for four or five sessions a week weren't exactly thick on the ground.

She rearranged her hair and carefully adjusted her hat, checking her appearance in her hand mirror, then stepped back from behind the screen to take her leave of the old artist.

He was still working on his statuette, and he barely paused to give her a loose handshake and mutter, gruffly:

"See you tomorrow. Ask Zoé to give you your hundred sous."

The young woman went down a floor and knocked at the door on the right that led into the kitchen. The little maid, a country girl with an ingenuously curious air, came immediately to open it. As soon as she saw it was Pauline, she shouted behind her, toward the rear of the kitchen:

"Auntie, it's the model!"

Pauline heard the dragging steps of the old governess, a gray-haired and corpulent woman, sixty or so years old, who finally appeared.

"Is that you already, Ms. Pauline?" she said, her kind,

fleshy face contorted with worry. "Has Monsieur Degas taken ill?"

"No, no. He let me leave a little early because I was too tired to hold the pose properly. But what's happened today to make him so mean?"

"It's his bladder that's bothering him again. You know that always puts him in a black mood."

She added, with tears in her eyes:

"Did you see how he treated me this morning because the fire wasn't burning as it should?"

"I did!" Pauline said. "He certainly wasn't very nice about it. How can he treat you that way when you've worked for him so long!"

"For almost twenty years, miss. And I do everything I can to keep him happy, which isn't always easy ... You know, this morning he didn't even want to give me my five francs for the day's expenses. I think I told you he gives me five francs every day to buy food for the three of us: for him, and for my niece and me. You've seen the price of food these days! You know that really five francs is not very much, even if he does pay for the wine, and gas, and coal separately. Well, this morning he didn't want to give me anything at all, supposedly because the chicken we're going to eat at noon was sent to him as a gift by one of his friends."

"Oh!" the young girl exclaimed. "What a miser!"

"You said it, miss, especially when it comes to food. But when it comes to buying paintings or drawings he manages to come up with the money, you'd better believe it!

But I'd better get started on lunch—here are your five francs, miss."

"Thank you, Madame Zoé. See you tomorrow."

*

* *

Just before nine the following morning, Pauline arrived at 3, rue Victor Massé,[2] with the vague hope in her heart that she might find Degas bedridden for the day. If that were the case, like all the other times he'd been too unwell to work, she'd be met by Zoé at the door of the third floor and led to the bedroom. Degas would speak to her for a few minutes, pay her for the session, and give her leave to go, free to enjoy the rest of her morning.

She hesitated on the landing of the third floor, hoping Zoé would emerge. But she waited in vain: the two doors of the apartment remained closed. Disappointed, she went up another flight of stairs and rang at the door across from the fourth-floor landing.

As always, it was the old governess who answered the ring, and led her down a dark, narrow corridor into the dining room. From the threshold, Pauline saw Degas turn toward her, an inquisitive expression on his face. She knew his sight was too poor for him to recognize her, so she called out brightly:

"Good morning, Monsieur Degas! How are you today?"

"Ah, it's you, Pauline," he said with a cheery smile,

reaching out to shake her hand. "Good morning. Take a seat on the couch."

She settled into the black leather couch next to the fireplace. Carefully scrutinizing the lines of Degas's face, she was glad to see that yesterday's surliness had dissipated overnight. His eyes seemed soft and gentle and his general demeanor serene.

He was in the middle of his breakfast and ate without haste; from time to time he glanced at Zoé, who, after showing the model in, had returned to her place next to the window. After she'd adjusted her eyeglasses, the old governess resumed reading aloud from an article in *Libre parole*,[3] a task that Pauline's arrival had temporarily interrupted. Degas listened with an attentive expression, nodding slightly here and there to signal his agreement with the author.

The young girl was soon tired of following Zoé's monotonous, rapid patter, and, distracted, she looked around at the little room she knew so well.

It was hardly any more cheerful than the atelier. A few chairs, a couch, and some very simple sideboards, painted brown, were placed along the dark walls, and a long, white wood table, sanded every morning by the maid, held pride of place in the middle of the room. A sewing machine, Zoé's property, sat next to the thickly curtained window giving onto the street, and overhead a string of gas lamps of varying dimensions and shades hung from the ceiling.

The only notable object of luxury, a drawing of the

head of a young woman wearing a turban, leaned on top of one of the sideboards.

Pauline still recalled the surprise she'd felt the first time she'd seen this modest interior. She'd learned afterward that this room was also a sort of office: the two maids, who slept in the room next door, worked most of the day here except when Degas was taking his meals.

Only in summer did the aging artist return to his real dining room, an attractive space at the other end of the apartment, opening onto a little garden. To get there you had to walk down the hallway and through a large salon stuffed with paintings and drawings. You came at last to a little room where there were some chairs whose backs were marked with a large letter D, a few tables and a desk of an unusual shape, and a large glass case with all sorts of charming curios inside, side by side with statuettes in plaster that Degas had modeled himself.

The drawings and tableaux gracing the walls had captured Pauline's interest. But the old artist did not tend to think that models should bother themselves with these sorts of things, to put it lightly, and so she'd never dared examine them up close. As long as the weather was warm enough, Degas took his meals in the dining room, returning to the stove-warmed office when the season changed again. As it was December, the tenth of December 1910 to be exact, Pauline told herself that she could look forward to many more mornings in the simple room where she now found herself before she'd have

the pleasure of reentering the other, much more interesting dining room ...

"Tatatata!" Degas shouted, suddenly furious. "My God, Zoé! You read deplorably—stop this instant! No one could ever understand a single word of it!"

The old governess stopped clean, without finishing the sentence she'd begun, and took off her eyeglasses. She was long habituated to being interrupted in exactly this way. The three of them shared a brief moment of silence, until Zoé said, articulating each syllable clearly in her ordinary speaking voice:

"Monsieur, I've repaired your jacket for you."

"Good," Degas replied. "I'll wear it this afternoon when I go out."

He turned to Pauline and explained:

"Zoé took up the cuffs of a jacket I bought for eighteen francs the other day at Place Clichy. Does that sound too expensive?"

"Lord no!" the young girl replied. Her eyes strayed involuntarily to the worn-out, filthy jacket Degas was wearing at the moment. "I would've thought a decent jacket cost much more than that."

"But as you are well aware, monsieur," Zoé continued, "you have no more shirts or socks either. We'll need to go to the Bon Marché and buy some."

He pretended not to have heard her and turned to face Pauline.

"Who are you posing for this afternoon?"

She dutifully told him she had an appointment to pose for Blondin, but Degas wasn't listening to a word she said. He swallowed the last mouthful of coffee, tossed his napkin on the table, and sprang to his feet. Collecting his hat from the sideboard, he left the room, climbing the stairs to the fourth floor so quickly that the model could barely keep up with him.

When they'd almost reached the landing, they heard Zoé hollering breathlessly behind them:

"Monsieur, monsieur! You didn't leave me any spending money!"

Degas whispered to Pauline with a mischievous smile:

"And here I was thinking she was going to forget to ask me for it!"

He waited until Zoé had caught up with them to hand her a gold coin:

"Here's ten francs, five for Pauline and five for our food ... But I remind you that yesterday we had a chicken sent to us for free by a stranger!"

*
* *

They entered the atelier.

The young woman didn't waste any time shedding her clothes, leaving them behind on the bench to huddle close to the stove. She found Degas carefully removing the scraps of cloth that covered his statuette, turning it from side to side to examine it from every possible angle,

his head bent oddly forward as usual. He stoked the fire and stopped short in front of Pauline unexpectedly.

"How many times a night do you get up to piss?"

"Me, Monsieur Degas? Never!"

"Ah! how marvelous it is to be young! Never having to get up in the middle of the night to piss! I have to do it at least six times." He sat down in his chair and repeated: "Yes, six times, every night. But tonight, at least, I think I'll suffer a little less. Zoé is going to make me some cherry bark tea. She thinks it'll do me good."

"Is it still the bladder disorder bothering you?" the model asked.

"Of course! I'm worried they'll have to put in a catheter! I've heard it's painful. In any case, I'm terribly afraid of it."

He fell silent for a moment, and then continued, in an infuriated tone:

"Isn't Zoé annoying? 'Buy some shirts, monsieur! You need some shoes, monsieur!' She's been nagging me about it after every meal for the past fifteen days, and I just bought a jacket!"

"But Madame Zoé is so frugal! I'm sure she'd never make you buy something without a good reason."

"I know it," Degas replied with the same mischievous smile on his face. "But I wait until the very last moment anyway. It annoys me to no end to have to spend money on things like that … And it annoys me even more to do it in the shops, always having to wade through a herd of women."

"You could just send Zoé," Pauline said.

"Hmm. I'd rather just go myself. It's one way to while

away an afternoon. But tell me, Pauline, what is it that makes women want to go stampeding into the stores, groping in ecstasy at bits of lace and silk, running from one counter to another, jostling each other, tearing bits of cloth from one another's hands? And the envious or disdainful stares they level on one another because this one is more fancily dressed than her neighbor! Women are so cruel to each other, with their coquetry that comes before everything else, husband, children, housework! Are you as preening as all that, Pauline?"

"Me? I barely have time to go running around department stores. But I do need to go to buy a bit of silk for my mother's birthday soon."

Degas immediately soured at her words.

"A bit of silk? For what? So your mother, the fine lady, needs to be dressed in silk? You're too good to do as I do? I bought my sister and all my nieces flannel for New Year's, enough to make dressing gowns with. Now that's a useful gift!"

Pauline was fed up. She bit her lip. Why talk about her business with this old bat, who himself never bought any clothes except when his own were so dirty and ravaged that his friends started to mention it, even making discreet remarks about it to his face?

She looked for another topic of conversation.

"Did you have a nice walk yesterday, Monsieur Degas?"

"Yes! Well, good enough anyway. I took the tram at Place Pigalle up to Porte de Vincennes. When I got there I walked a bit around the fortifications, then I took another tram

all the way to Saint-Augustin. And from there I wandered home."

"Oh, that sounds like a lovely walk! Almost as long as your excursions to Montmartre."

"I'd believe it! I think I'll go to Montrouge this afternoon and tomorrow to Auteuil. Or somewhere else, it doesn't matter, really. Sometimes I just get in the first train that comes by and ask the conductor where we're headed. When I've done all the different neighborhoods of Paris, I'll get back to wandering Montmartre, which I still think is the best out of all of them. When I walk there I know all the streets at least, so I never need to ask my way. But really it doesn't matter whether I walk there or somewhere else. My poor eyes have gotten so bad that I can barely make out where I am anymore."

"It's not very prudent to go wandering around like that all alone," Pauline said. "The streets are full of all those carriages, and trams, and cars!"

"Zoé tells me that every single day. If I'm even a minute late getting home she thinks I've been run over dead in a road somewhere. But I can't spend all my time cooped up here; I need fresh air just like everyone else in the world."

"And so you hop about like a jackrabbit! The last time I saw you, it was near the Moulin Rouge; you were heading up the rue Lepic so quickly that I almost couldn't catch up with you."

"My legs haven't gone just yet!" he said, laughing. "But even still, I don't like to go out at night too much because

the streets are so badly lit. I rarely accept a dinner invitation, if ever."

"In any case, if you did, you'd get to bed rather late. I thought you were usually asleep by nine?"

He didn't respond. Settled deep in his chair, a hand over his eyes, he sighed deeply.

"Ah! my girl, it's awful to lose your sight! I had to give up drawing and painting years ago. Now I settle for sculpture ... But if my eyesight gets any worse, I won't even be able to do that much. What will I make of my days then? I'll die of boredom and disgust!" The artist heaved a sigh. "Ah! Lord, what sin did I ever commit to deserve such a punishment? I devoted my entire life to my work; I've never gone chasing after honors or money ... Ah! my God, don't torture me! Don't let me go completely blind!"

The young girl was moved by the depth of grief in his words, even though she'd heard them a thousand times before. She did her best to console him:

"No, Monsieur Degas, you're not going to go blind. You can't let yourself think that for a second! Your eyes are just tired from the cold. I'm sure you'll feel better as soon as the warm weather returns."

"Do you think so, Pauline?"

"Certainly, Monsieur Degas. And you'll see, your doctor will tell you exactly the same thing I'm telling you now. He'll say you're in astounding shape for your seventy-six years. Think about it: you work every morning, you don't even break on Sundays or holidays. There are plenty of artists younger than you who don't do as much. And

you've still got your appetite, you don't have trouble with your digestion, you sleep well, you don't have rheumatism like your old friend M. Rouart." [4]

"But Pauline, you're forgetting my bladder disorder."

"Well that's what you get for your disreputable youth," the model joked.

"Ah, that old mischief! Who even remembers my secrets now ..." [5]

He laughed, and, leaping to his feet, shed his jacket to put on the large smock. Degas went to sit down in front of his statuette.

Pauline was not surprised by his sudden decisiveness. Almost every morning went this way. For a longer or shorter span of time, some days as long as a half hour, he'd sit in his armchair and chat about this and that or would ask the model about the other artists she posed for, putting off as long as possible the moment when he'd have to get down to work.

Then, all of a sudden, the impulse would seize him. He'd settle down in front of his statuette and, as he did this morning, wait impatiently for the model to assume the pose.

Pauline hurried to comply, climbing nimbly up onto the platform. She performed the movement, and, unlike the day before, Degas seemed infinitely forbearing. He was satisfied with gently pointing out a little correction or two in the pose. As usual, he went from the model to his statuette and back, to trace some detail of the naked body with his thumb that he'd then mold in plastiline. [6]

He hummed an aria from *Don Juan* in Italian, always a sign he was in a good mood. Pauline listened with pleasure to his rich, expressive voice. He knew many Italian operas by heart, and some days he would pass the entire morning singing all kinds of arias, translating them for Pauline's benefit. "Isn't that just delightful?" he'd exclaim.[7]

But this morning he was soon totally absorbed by his work. As sometimes happened, he began uttering nonsensical phrases that amused his models even more for the fact that he gave them a serious, doctrinal air, emphasizing each word.

He spoke of a green and tender princess, wracked with love and fleas, who walked through the ruins of Art; then of a tiger wearing a jockstrap, who pissed down the ramparts of Art; then of an amorous red serpent who adored spices and Art, and who devoured her children; and so on. The litany always wound up with: Ah! the camel of Art!

Once he'd recited all these phrases, already familiar to the young girl, he suddenly came out with a sequence of words so dirty, of such an excessive filth, that Pauline, whose modeling career had not exactly tended to make her prudish, let out a shocked gasp.

He fell silent, surprised.

"But what's wrong, my dear girl?"

She didn't want to repeat the foul language she'd heard and said:

"Monsieur Degas, you just said some things that would make an old soldier blush!"

"Poor girl!" he said, needling her. "Have I offended your

chaste ears? In that case, just don't listen. I'm so absorbed in my work that I speak without even knowing what I'm saying. All right, now show me the pose."

The session continued in silence, until Pauline, tired of one-legged gymnastics, requested a break.

Huddled next to the stove, she tried to remember the melody of the *Don Juan* minuet. When it didn't come back to her, she said:

"Monsieur Degas, would you mind teaching me the pretty little melody you were singing earlier?"

"Of course, my dear. I'll sing it for you."

He stood in front of Pauline and sang the melody, bowing and saluting to the young girl, gestures she repeated back to him, laughing at the comic tableau they made together: her, totally nude except for a pair of sandals on her feet, and him, an old, gray-haired man, dressed in his long sculptor's smock.

Degas was in an excellent mood. As soon as the minuet was over, he clasped the model's two hands in his own and spun her as he launched into an old French song.

He collapsed into his armchair, half-dizzy, and said:

"I don't think there's anything in the world more beautiful or graceful than these old French rounds, do you?"

Pauline agreed. She was glad to see him so cheerful, and even the atelier seemed to her less gloomy than it had the day before. When she resumed posing after a few minutes' rest even that awful strain was almost tolerable. It still took all her strength to hold it, while Degas stood in front of her, checking with his plumb line that the lines

of the model's body and those of the statuette were ab-
solutely identical.

They were working steadily in total silence when Zoé
came in, interrupting the session. She placed a small
stoneware pot on the table next to the armchair and left
again, after announcing:

"Monsieur, your infusion."

"Ah! my infusion," shouted Degas as soon as she'd
closed the door behind her.

He sniffed it, drank a mouthful, and offered it to the
model:

"It's good, try a sip."

Pauline, teasing him, pretended to drink off the entire
contents of the pot. Degas begged her to leave him some,
and, after drinking again, he said:

"So, you think my bladder disorder comes from too
much carousing in my youth?"

"It was you yourself who told me so!"

He laughed:

"It's true—I caught something or other, like most
young men, but I was never much of one for carousing."

"I'm not sure I believe you," Pauline teased. "Who knows?
Maybe you still go chasing after girls even now! When Zoé
thinks you're sleeping peacefully, maybe you've crept out
to the Bal Tabarin[8] across the way to dance a jig!"

"Ha, you think I'm that much of a hedonist? Well, don't
be fooled. I may live directly across from a dance hall but
I've never set foot there even once, because of those flood-
lights I can make out when they open the door … It's true

though that I do love awfully harsh lighting, but these days my poor eyes can't take it anymore. I have to avoid it as much as possible. That's why I always keep the curtains in the atelier lowered: the light is too painful for me."

His voice had become melancholy. Pauline kept up her chatter in the hopes of driving off his depression.

"Come on, Monsieur Degas, I know you well enough to be suspicious of this false candor of yours. With you I'm always on my guard."

"As well you should be, my dear girl! I'm a terror when that sort of thing gets a hold of me. And you'll see: one of these days I'll start taking after Puvis de Chavannes,[9] who used to say to his models, 'How'd you like to see a great man's cock?'"

"Disgusting!" the young girl cried. "And I'd always thought he was so distinguished!"

"One doesn't necessarily preclude the other," Degas replied.

He came close and whispered in her ear:

"Listen, Pauline. I'd be grateful if you'd lead the other artists to believe that I'm still just as much a rascal as I ever was. You'll tell them that I tried to make you 'suffer the most outrageous abuses,' as people these days so elegantly put it, and that it took all your strength to keep me off of you."

"Understood, Monsieur Degas. When I'm finished, you'll have such a bad reputation that Chavannes will seem like a choirboy compared to you."

He rubbed his hands together, satisfied.

Pauline watched him with a smile on her lips. It was funny to see how much he wanted to pass for an old libertine, when, aside from his filthy tongue, he was always perfectly proper with his models. He never allowed himself the least intimacy, let alone any kind of tryst.

They had begun to work again, and the silence was interrupted only by short comments from Degas.

Pauline soon started to feel the effects of fatigue again, and she asked if she could come down from the platform. While she rubbed the tension out of her legs and back, she examined the statuette, sighing when she saw that it didn't seem to have progressed any further today from where it had been even as long as three months ago. At this pace, she told herself, she'd be stuck with the grueling pose for months to come so long as Degas didn't just give up on it altogether.

She knew that wasn't very likely. He would do what he so often did: one fine day he'd cease working on it and put it away on the long table at the back of the atelier. The statuette would take its place among the half-dozen other figurines, all the same scale at one-fourth life size, some molded in plastiline, others in clay, all of which had been abandoned by Degas after months of relentless work.

He did take good care to preserve them, fully intending to return to them someday when he'd grown tired of something else. Long months or even a year would pass before he'd be gripped with the sudden desire to work again on one or another of these dormant figures.

There was always an unpleasant surprise in store: the

very first session with one of the recuperated figurines, an arm or a leg would inevitably come unstuck from the torso. He'd repair it only to find another flaw or mishap somewhere else a day or two later.

When the figurines were made of plastiline it was easy enough to return the statuette to its proper shape, but the ones in clay couldn't really hold up to being mended like this. They crumbled at once, and there was nothing left to do but to pick up the pieces and throw them into the bin.

With melancholy, Pauline imagined the dire fate of "her statuette."

"Her statuette" was a clay figurine, in a pose identical to the one she was currently holding. Degas had begun work on it almost a year ago. For months on end, Pauline came to pose for it almost without interruption, sometimes even twice a day.

She had been so happy to see the statuette coming along, as Degas refined the design and the forms became more and more energetic. She felt an enormous sense of pride when she thought that one day "her statuette" would be cast and displayed in the glass case below, because it had been years since Degas had cast any of his sculptures. But she shook with anxiety every time she saw the old artist, never satisfied, try to improve it by separating the elbow, lifting the knee higher, twisting the torso … The statuette hadn't been put together very solidly in the first place, shaped by Degas's maladroit painter's hands. How could it possibly survive all these continual little distortions?

The answer was: it didn't.

One morning, Degas found it crumbled on its stand; only the head and a part of the torso were still clinging to the wire skeleton. His arms hanging at his side, the aging artist took in the sight of this disaster. As for Pauline, when she saw what had become of "her statuette" she let out a sad gasp.

He at least had the heart to joke:

"I'll make a seated woman from the remains."

But soon he became defiant:

"We start again."

That very minute he mounted a new statuette in plastiline on the plank. But he couldn't muster the same enthusiasm for it, and he abandoned it two months later to begin a completely different figure. The new pose was just as exhausting and Pauline wasn't in the least sorry to see this second statuette relegated to the back of the atelier after a few short weeks. And then the woman who examined the sole of her foot made her return.

They worked again for some months on this figure, four sessions a week, without making nearly the kind of progress one would normally expect from so much effort.

The truth was that Degas had stayed faithful to his painter's methods, and whenever he wanted to modify the pose, he destroyed an arm or a leg bit by bit in the course of repeatedly reshaping it. His mania for stuffing the statuettes with little rounds of cork caused even more problems. And of course, his failing sight didn't exactly help speed things along.

Lost in these thoughts, Pauline had stopped paying attention to the old artist. She almost jumped when she saw that he'd crept up next to her to whisper in her ear:

"I'm always thinking about death these days. Day and night, I can always see it in front of me ... Ah! it's so sad to be old! You can't understand these things when you're only twenty-five, my dear girl."

He collapsed in the armchair and covered his eyes.

Half-annoyed and half-moved, the girl gazed at him. Her robust, youthful temperament was shocked and offended by these daily lamentations of his, always phrased in nearly the exact same terms. But she knew that he loved to be consoled, so she said:

"Come, Monsieur Degas, why must you always talk about death? You're only seventy-six years old; you've got plenty of time to think about it later ... I'd bet you'll live longer than Harpignies,[10] and he's in his nineties now!"

"Ha, yes, there's always old Harpignies! It's true, he's still here and doesn't seem likely to ever want to give up the ghost."

He chuckled and sat for yet another minute or two, lost in his thoughts.

"I really like your name, Pauline," he said all of a sudden. "It's a simple name. Do you know what mine is?"

"Of course I do, because you told me, Monsieur Degas! Don't you remember how I tried to guess it for ages?"

"Lady, you could never have guessed that I'm called Edgar! ... Edgar! ... Can it even be legal for your parents to pin a name like that on you? When I was born, it was

1834, the age of romantic names; so my parents did what everyone else was doing ... Ah! have I already told you about my grandparents? They were old emigrants who left Paris during the revolution to become bankers in Naples ... I still have family there."

"Oh, yes!" Pauline said. "You're supposed to go visit them at some point, I thought."

"Not anymore," Degas lamented. "I can't see well enough to go gallivanting so far from home.[11] But I went quite often in my youth. Once I was there with Gustave Moreau.[12] I asked him one day what could possibly be causing this itchiness I'd been feeling everywhere on my body. He told me: 'Either you have crabs, or you don't.'"

The model laughed out of politeness, not at the anecdote itself, which she'd heard a thousand times already alongside a handful of others that made up his repertoire. He especially loved to tell the one about his time in America. Thirty or so years ago, Degas went to stay for some long months on plantations belonging to one of his uncles.[13] One day when they were out on a boat he heard a dockworker express himself in the purest Parisian slang. He was so moved by hearing the familiar accent, a sound he'd been deprived of for so long, that tears came to his eyes.

Instead of these stories told for the twentieth time, Pauline would have preferred a few gossipy details on the famous people Degas had known over the course of his life. But the aging artist was suspicious of her curiosity, and as soon as she asked some insinuating, sideways

question, to know if he'd been close to so-and-so, what such and such was like, he looked her straight in the face and said, with a malicious gleam in his eye:

"I see you creeping up on your little elephant feet. Ah no! You won't get anything from me!"

This morning he was satisfied with a single anecdote and moved on to another subject.

"So, this afternoon you're going to pose for M. Blondin, who isn't blond at all, is he?"

"Not in the slightest. He has jet-black, curly hair and a beard to match."

"Is he a Jew?"

"I don't think so, Monsieur Degas."

With a brutal tone, Degas said:

"I detest them, those Jews! An abominable race that ought to be shut up in ghettos. Or even totally eradicated! During the wars, those miserable creatures prowled the battlefields robbing corpses and finishing off the wounded, like the hyenas they are ... They don't even have a homeland, and now they've overrun France; they've snuck in everywhere, they've stolen all the best positions for themselves!"

He shrugged his shoulders and continued:

"They like to think they're clean, because they take those baths of theirs and perfume themselves all over, and dress in the latest fashions, as if propriety meant just washing one's hands instead of having anything to do with one's morals and character."

Degas was more and more worked up. He took hold

of Pauline's wrist, gripping it with all his strength:

"I never go into a store if I know it's owned by a Jew. And if Zoé ever brought me anything she'd bought at ****, for example, I'd throw it straight out the window!"

He shook the model's arm furiously, as if it, too, was one of those detested Israelites, and marched up and down in the atelier, his face red with anger. Pauline fell silent; she had no desire to admit that, as a matter of fact, M. Blondin was indeed a Jew. Degas was perfectly capable of firing her for consenting to pose for such a man.

When he'd finally recovered his calm, the old artist asked her:

"Does he behave appropriately with you, this Monsieur Blondin?"

"Of course, he's just like any other artist. Good God, but he doesn't hold back when it comes to dirty jokes! That's as far as he goes, though."

"Ah! he's just like any other artist," Degas echoed her. "But, Pauline, isn't it true that people imagine artists and their models get up to all sorts of foolishness? As for work, well, you paint or sculpt when you finally get tired of fooling around ... And when they talk about dancers, they imagine them as lavishly kept, covered in jewels, with an apartment and car and servants of their own, just like in the novels. In reality most of them are just poor girls who work a demanding job and barely make enough to live on ... I know them well, you know, the little rats, from the time when they used to come and pose for me."

Pauline, who'd been examining the figurine of a

dancer on a nearby stool, said, "How hard it must be to stay balanced on just the toes of your feet! How does Yvonne manage to pose like that for you? I couldn't hold it even for a second!"

"And did I ever ask you to?" Degas shot back, roughly. "It's not in your line of work. Let's get down to it, but don't climb up on the table just yet. Stand here next to me so I can work on the head."

The model was so close to him now that the old artist could reach out his hand and touch her. Each time he fumbled with her face or neck, his fingers left behind smears of greenish plastiline, annoying her to no end. She would've been more forbearing if at least Degas had actually copied her features, which, so she'd been told, were elegant and pretty. But he gave the statuette the same vulgar expression that had shocked her already when she saw it repeated over and over in his drawings.

As Degas turned the figure around, the young girl noticed a small hump in the middle of its back. It was one of those disks of cork he was in the habit of shoving into his statuettes—they always made it back to the surface eventually.

For a minute or two, she wavered, debating whether or not to point it out to Degas. In the end, she did nothing. Degas didn't like to think that a model was paying close attention to his work. She continued to hold the pose, listening to him rattle out his mysterious pronouncements on the tender, green princess who pissed in the field of Art ...

After a half hour had passed, they took a break.

They talked about the rain, about when the fine weather would return. Pauline rubbed feeling back into her numb left leg and Degas remarked:

"You're doing just what the dancers do: they're always busying themselves rubbing their calves, Yvonne more than anyone … Did I already tell you the poor girl is bed-ridden with typhoid fever? I went a few times to see how she was doing, but now I don't dare to go back. It might give the concierge something to gossip about. What must she think of an old man like me who comes to ask after the health of a sick dancer!"

They returned to work for the final segment of the session. Pauline, more and more drained, kept her ears pricked up, listening for the clock of Sacré-Cœur to sound her deliverance. She finally made out its deep bass tone, barely audible over the continuous bustle of carriages in the street outside. The young girl said brightly:

"Monsieur Degas, it must be getting near noon!"

"I don't believe it. And here I was just getting down to work! Come, hold the pose steady while I take a few measurements."

The sharp points of the compass danced in front of her face as a handful of minutes passed, making her shudder more than once out of fear for her eyes. At last, Degas said:

"Go on then!" And Pauline ran back to her bench.

When she'd taken her leave of the old artist, she went down to knock at the kitchen door. Zoé came to open it

and, handing the model the day's pay, asked her:

"Is monsieur in a decent mood today?"

"Yes, yes," responded Pauline. "He thought your infusion was excellent."

"Don't you find it annoying that he never wants to lay out any money for clothes when he so obviously needs them?"

"You have to insist, Madame Zoé. He'll listen to you in the end. I'm in a rush today—so long!"

*

* *

When the young maid led her to the dining room the following morning, Pauline was startled to find Zoé there with her friend Juliette.

"Hold on," said the governess. "Now we have two models for a single session."

"You're also here to pose, Juliette?" Pauline asked.

"Of course. Three days ago, I received a letter from Monsieur Degas asking me to come this morning. Here it is, see for yourself."

She handed the letter to Pauline, who read:

> *Juliette, could you come on Saturday?*
> *Reply straight away if you can't make it.*
>> *Good day,*
>> *Degas*

Pauline returned it with a laugh.

"I've received plenty just like it myself, not a single

word of explanation. Even so, in a letter, he could at least address us as 'Mademoiselle.' He has to put it on the envelope anyway! But as for the session, I'm absolutely certain that he's booked me for this morning."

"Don't let there be any bad blood over this, my girls," Zoé intervened. "Monsieur will keep one of you to pose and he'll let the other leave with her five francs. This isn't the first time a morning cost him ten francs. He doesn't spare any expenses when it comes to his work. But shush, here he comes ..."

His hat thrown back on his head, Degas appeared in the doorway. He shook hands with each of the models and said to Juliette, slightly embarrassed:

"My dear, when I wrote to you to come this morning, I didn't know Pauline would be free. But since she's free, I'm going to work with her, to make progress on my statuette. You can come back in fifteen days from today. Is it a deal? ... Here are your five francs. Goodbye, Juliette."

Just as she was nearing the door, he called out:

"Wait a second! Tell me, are you still working for that ass, Monsieur ****?"

"No, I don't pose for him anymore."

"Ah! good!"

*

* *

As soon as he'd finished his breakfast, the old artist climbed up the stairs to the atelier and his model followed

behind him. Shedding her clothes in the corner, Pauline heard Degas let out a gasp. He said in a sorry voice:

"I must have been a complete moron to put corks in this figurine! Even as imbecilic as I am, with my mania for scrimping and saving for two sous! Now the back is ruined! ... Oh! how did I ever get the idea to start messing around with sculpture at my age? What a farce for a painter! Now I'll never get out of it."

The young girl listened to him moan with a sardonic smile. She knew that at the very next opportunity he wouldn't hesitate to stick bits of cork in his statuettes so as to save on plastiline, the price of which he thought exorbitant. And when, thanks to having pushed an arm or a leg too far forward or backward, one of these little disks came back to the surface in the exact place he least expected, the litany would begin all over again: such an imbecile, such a miser ...

Pauline emerged from behind the screen, and she saw Degas busying himself with filling in the hole that the removal of the disk of cork had left behind. She told herself: Yes, it's true, the statuette was certainly not any nearer to being finished. But when she saw the serious expression on Degas's face she didn't dare try to engage him in a conversation. She retreated to the stove instead, in the hopes that Degas would finally speak to her at some point.

The minutes ticked away and the artist was still lost in thought, sunk in his armchair. He broke his silence to ask the model about her session yesterday and wanted

to know if M. Blondin had been awarded a medal at the Salon, if he'd been decorated, if he was ambitious.

"Oh, yes," Pauline said, "he's certainly ambitious! He always plays the big man when I'm with him, strutting around the room with his second medal. And he's beginning to make overtures to some very influential individuals."

"Ha! Aren't they absurd with their silly medals!" Degas said with a shrug. "Those people don't talk like we do, saying that such and such a thing happened in such and such a year. No! They say, it was the year I won my medal, or my first prize, or my purple ribbon, just like women say, the year when I had my nice velour dress … And to think that even my friends, my best friends, go chasing after honors and distinctions and talk of nothing but salons and expositions! For my part, I think a true artist wouldn't have anything to do with stupid shit like that. If an artist has any real talent, he can show his work anywhere, even in the window of a cobbler's shop. It doesn't matter. He'll still find people who will notice and appreciate him."

"But you used to show your work too!" Pauline said. "The other day I read a pamphlet of Huysmans's in which he had plenty to say about you."

"Huysmans?" said Degas with disdain. "He's an ass. What got into him to make him want to poke his nose into painting. He doesn't know the first thing about it! But all these literary hacks think they're perfectly capable of writing art criticism. As if painting wasn't the least accessible thing in the world!"

He stood and stepped close to the young girl. Marking his words with emphatic gestures, he said:

"What are these times we live in, Pauline, good God! Now there are even *models* who come around wanting to talk to you about art, painting, literature, as if it were enough simply to know how to read and write to really understand anything. Before all this, weren't they all just as happy without this useless education the schools force on them? Zoé's two brothers, a butcher and a carter, don't know how to read or write and they're no worse off for that."

The old artist began to wheeze as he became more and more excited:

"Now everybody wants to vulgarize everything: education and even art! No one talks about anything but popular art anymore. It's criminal! Total insanity! As if artists themselves didn't already have enough trouble just figuring out what art really is! But all of this comes out of those so-called egalitarian ideas. What villainy to talk about equality as if it really existed when there will always be on one side the rich and, on the other, the poor! It used to be everyone stayed in their proper place and dressed according to their station; now even the poorest grocer's son reads his newspaper and dresses like a gentleman. What a shameful century!"

He'd worked himself up so much he was sputtering and drooling as he ranted, and his eyes shined fire at Pauline, who stood in front of him, unmoving, her head down.

She swore at herself for having triggered this outburst. But she was long familiar with the old artist's ideas, and

she knew it was taboo for models to trespass on the artist's own terrain, in the same way it was forbidden for Zoé to sweep any bit of the atelier other than the little prearranged area. More than once she'd gotten herself sternly rebuked for some comment she'd let slip, or even for forgetting to hide a book or newspaper she'd brought with her.

On her tongue there always the quip that if Zoé were as illiterate as her brothers she wouldn't be able to read his mail and his newspapers for him. And, as for models, it was the artists themselves who often encouraged them to try their hands at painting or sculpture.

But she'd never dared say out loud what she secretly thought, certain that such a discussion would have no other end for her than Degas firing her on the spot. So she held her peace, as she had so many times before, cursing her own absentmindedness for having triggered his outburst. Now she knew she could look forward to a morning of glacial silence.

Which is precisely what happened. Without a word, Degas seated himself in front of his work and Pauline climbed onto the platform. Minutes and hours passed with nothing to be heard except for a few brief words from Degas or the voice of the model requesting a break. Even the arrival of Zoé did nothing to break the silence. Degas drank his infusion alone without offering any to Pauline, and the session began anew.

Today she was posing from behind. This left the young girl's mind free to wander, her gaze drifting over the

screen and across the piles of furniture, old boxes, and frames black with dust that filled the middle and back of the atelier.

It wasn't a cheerful sight. Pauline would have preferred to look at the little room in the back that Degas had shown her one day when he was in a particularly good mood.

He had so many paintings in there! Big canvases and small ones, and boxes stuffed with pastels and drawings, and an etching press in the middle of the room. Pauline wanted to linger and look at everything closely. But Degas, after he'd led her once quickly around the room, led her just as quickly back into the atelier.

Pauline was beginning to think she might die of boredom when the total silence was broken at last by a timid ring of the doorbell.

Degas stood up and adopted his most off-putting expression.

"Who could be coming to piss me off now?"

His body stiff and head thrown back, he went to open the door. Pauline heard an insinuating voice say, "Good day, my dear master!"

"There are no 'dear masters' here!" Degas shouted back, and, wham!—slammed the door in the caller's face.

Visibly furious, the old artist sat back in front of his work, grumbling:

"Must've been one of those dickhead art critics!"

Pauline almost burst out laughing when she imagined

the expression on the gentleman's face as he went off empty-handed. Here was a poor soul who certainly didn't know much about Degas. If he had, he would have known that no one, not even the artist's closest friends, dared to disturb him when he was working. It was only at meal-times or in the course of the afternoon that anyone could pay him a visit.

The young woman could remember only a single time that Degas had let someone in during a session.

It was a short, rotund man, very lively in spite of his white hair, who had come to visit Degas for a long conversation. When it was finally time for him to leave, the visitor, gesturing toward the large canvas of dancers, said:

"Give me that one, I have a buyer."

"But anyone can see it isn't finished!" Degas replied.

"But it's perfectly fine as it is," the gentleman insisted. "Give it to me."

"You have no idea what you're talking about!"

And he swung the door to the atelier wide open to show his visitor out.

For the fiftieth time, the model assumed the pose. Boredom and fatigue were making the morning seem absolutely interminable.

She was angry, too, with the old artist, for his sour temper, and for whatever madness it was that led him to assign nothing but strenuous poses.

Never, even when his sight still permitted him to make pastels or drawings, he'd never asked one of his models for an easy movement. It always had to be an action pose,

and to hold it you'd have to arch your back and tense your muscles down to the fingertips. The sight of a rounded back or a sloppily positioned hand could make him howl with anger.

Pauline thought about how odd it was, this aversion on Degas's part to any easy grace and his constant search for poses that captured some vigorous action at its tensest moment.

At the same time, he wasn't blind to the harmony of line or the beauty of forms, she knew, since he'd often praised his model's body: her beautiful legs, her charmingly plump arms, her delicate joints.

But he couldn't stand it when Pauline put rouge on her lips or did her hair up in the latest fashion. Even with his faded eyesight, he'd never fail to notice and, digging his fingers into her hair, he'd tug on it with all his strength:

"When someone is as young and fresh as you are, there's no need to go playing the whore. Just stay as you were born! Natural, without all this frippery!"

It made her wonder why he so loved to paint the theater, where everything is a façade. But the question seemed too difficult for her to puzzle out, so she quickly gave up on it. No longer thinking of anything, Pauline mechanically held the pose. A furious grunt made her spin around and she was taken by surprise to see Degas threatening her with a hammer.

"I'd like to break your head to pay you back for how slack you are!" he shouted.

With a disdainful pout, Pauline looked at the little

hammer, barely big enough to pound in a tack.

"That's no tool for a sculptor! You'd need at least a stonemason's hammer."

"It's true," he said, beginning to laugh. "I'll never be any kind of sculptor."

He seemed suddenly in a better mood. He told Pauline to take a break and even offered her some of his infusion, which she accepted, pleased his sulk had finally come to an end.

They began to chat. Degas told her about the previous day's walk. He'd gone all the way to Porte d'Auteuil. While he waited for the train, he'd ordered a cup of chamomile tea in a café. They'd charged him the absolutely princely sum of sixty cents! Then he'd had the rotten luck to lose his ticket, which meant he had to pay twice for the same seat. As Pauline giggled at his bad fortune, he said:

"Ha, well! It's just that I'm quite vigilant when it comes to these small sums! It's harder for me to take twenty sous out of my wallet for my own bed and board than it is to spend a hundred francs for my work or my collection of paintings."

The session had begun again in earnest. Pauline, who was now posing next to Degas, was pleased to see an affable expression on his face. He hummed as he went, interrupting himself to say in a quiet voice:

"Oh, Monsieur Bartholomé![14] Do you know him, Pauline?" he asked the young girl.

"Only a very little, Monsieur Degas. But Juliette poses for him regularly."

"Ah! what a talented man! He can do anything he likes with his fingers: he knows how to arrange a framework, set up a figure, work marble. And the casters often come to his house ... Oh! how much I'd like to call for a caster too! But I never finish a single one of my sculptures. Nothing but catastrophes ever happen here."

"But I thought you had already cast at least some of your figures," Pauline observed. "In the glass case on the lower floor, there's a statuette with exactly the same pose as the one I'm holding now."

"Oh, yes," Degas said, "I modeled it ten years ago. That's the last time that the caster was called here ... The model who posed for it has since become a sculptor. It was Bartholomé who put the idea in her head. Now what could have driven him to fill her with that sort of nonsense? Naturally, she stopped coming here after that, since she could do my work just as well as I could ..."

There was another silence. Then the old artist asked:

"Tell me, Pauline, do other sculptors have accidents with their figurines?"

"Of course," the model said to comfort him. "It happens pretty often, even to the most talented ones."

As the two chatted away, the session came to an end. The young woman, ready to leave, extended her hand to Degas.

"One moment," he said. "Find me, if you could, my little daybook and see if the twenty-fifth of December is open so I can put down that day for Juliette."

"But that's Christmas!" Pauline said.

"Well then, so it is! But I'll be working regardless. How would I pass my morning if I didn't? God will forgive me for neglecting even my duties as a Christian so long as it's for my work."

In his rough handwriting he wrote down Juliette's name at the place that Pauline pointed out to him.

"Is it legible?" he asked.

"Perfectly."

"I write without being able to see it," he sighed. "Impossible for me to reread what I've written ... How sad it is not to be able to see properly anymore! ... So long, my dear, until next Monday."

*

* *

When Pauline entered the little restaurant on the rue de Douai [15] where she typically ate lunch, she found Juliette seated with Suzon, a lighthearted, pretty blonde, quick to joke.

She sat down next to her friend, who immediately asked her:

"Did old Father Degas ask you if I posed for Monsieur ****, the sculptor?"

"He didn't mention him, or you."

"Ah! so much the better. I was afraid that you'd already said that I was posing for Monsieur ****, and since you know that Degas can't stand him—"

"Which monsieur are you talking about?" Pauline

cut in. "The one who always has those commissions for monuments? The idiot who's so full of himself?"

"Yes, that's the one. Do you believe he didn't even recognize Degas's name? A year ago, as I was posing for him, he desperately wanted a session two days later as well and he would've moved hell and earth to get it. I told him that I'd already been booked by Degas. He asked me, 'Who's this Degas? I've never even heard the name.' And I said, 'He's an old painter who does sculpture now.' 'Ah! and where does he show his work? At the Salon of French Artists or at the National Gallery?' 'Neither—I think he's never even exhibited it at all.' Then he said: 'Wow, his stuff must be really terrible. Is he at least decorated? Does he have the violet ribbon?' 'Not even the violet ribbon.' 'Oh, the poor old man! Well, you tell him that if he'll agree to give me your session the day after tomorrow, I'll see what I can do to get him the violet ribbon or at least his name mentioned at the Salon. I'm very close to the minister of fine arts.'"

Pauline burst out laughing and Juliette said:

"I laughed too. Monsieur **** was perfectly annoyed. When I explained to him who Degas was, he tried to convince me that it'd been an elaborate joke on his part."

"Did you tell Degas about it?"

"No. I simply asked him if he wanted to give his morning session to Monsieur ****. The mere thought of it made him so angry that fifteen days later he stopped working with me entirely."

Suzon put her two cents in:

"You're both so brave, you two, posing for that old maniac! As for me, I only did it twice, and the third time he threw me clean out. He never told you about it?"

"He almost never talks about his models," Pauline replied.

"Well, here's what happened: I'd arrived a little late for the session, maybe half an hour. He was already in the atelier. When I rang, he ripped open the door like a madman, handed me a coin worth a hundred sous, and shouted: 'Here are your five francs. Now fuck off and never set foot here again.' And he slammed the door so hard the entire house shook. You can bet I had a good laugh at that old nutjob. I couldn't give half a damn about him and his stupid exhausting poses!"

*

* *

Some weeks later was New Year's Day, and Pauline was sitting in the little chair in the dining room, waiting for Degas to appear.

He soon arrived, looking solemn. Instead of his normal filthy outfit, he was wearing light-colored pants, and pearl-gray spats peeked out from beneath the cuffs. Even so, his black jacket was visibly on the short side and his bowler hat, Pauline thought, could charitably be called rather worn.

The young girl wished him a happy new year, to which he replied with a dry "thank you," and, sitting down in

front of his breakfast, he asked Zoé to read his letters. That day there were quite a few, primarily from family, warmly wishing him well for the year to come. Degas listened to them all, impassive.

Zoé's progress through the letters was interrupted by a ring at the door. The maid led in a young man who came to give his best wishes to his "dear relative." After they'd kissed one another on the cheek, the visitor animatedly asked after Degas's health, after news of this or that member of the family, whether or not he was planning any trips.

Degas responded in monosyllables between mouthfuls of coffee. He even cut the visitor off to ask the model if she was due to pose anywhere that afternoon. The young man didn't let himself be put off by it and resumed the conversation exactly where it'd been interrupted. But Degas stood up suddenly, presented his cheek for a farewell kiss, and said:

"So long. Say hello to your family for me. Pauline, let's go up to work."

*

* *

In the workshop, the young girl was surprised to find the modeling platform and the statuette's stand replaced with a bench and easels covered in pastels.

She examined them with curiosity. They were all either of dancers or women at their toilette. One of the figures,

a dancer at the barre, appeared in numerous pastels. In one, she was dressed in green and stood out starkly on a purple background. In another, the background was yellow and her costume was red, and in a third it was a pink tutu on a green background.

Pauline remembered that some time ago, near 1902, when Degas still drew, she'd seen him trace this drawing and copy the same one on many sheets of pastel paper. Then he'd paint it with different color schemes, varying the combinations of colors over and again. When he was happy enough with one of them he'd finish it, leaving the others in whatever state they happened to be in.

Degas looked at the figures one after the other and seemed indecisive. He finally chose a dancer seated on a bench with one leg stretched out.

After having pinned the pastel onto a box on top of a stool, he examined it up close and at length, his head leaning forward, while he recited his absurdities about the tiger who loved Art and dandelions. The model, sitting on her own bench, held herself ready to assume the pose. But Degas seemed incapable of deciding to get down to work. After a half hour had gone by like this, he said:

"Come here, Pauline. What color is this pastel?"

He pointed out a pink baton, and she told him the color, along with some others: light gray, dark blue, green.

"Thank you," he said. "Please sit back down. I'll tell you when I'm ready for you."

Full of pity, the young girl returned to her seat.

So he must've been almost blind if he could no longer

make out the colors, even with the curtain raised and a good deal of light coming in. How could he ever paint again now?

His colored pencils in hand, Degas hesitated. Finally, he applied a tentative stroke to the background of the pastel, then stopped to examine the drawing, his face rigid in intense concentration.

Pauline almost broke out in tears when she remembered the rapid movements he would've drawn with in the old days, compared to this painful trial and error. She left her bench and approached the stove, turning her back on the old artist to shut out the pathetic spectacle.

She had heard barely a handful of scratches of pencil on paper when all of a sudden the dull thud of a heavy body hitting the floor echoed through the atelier.

Degas had fallen completely over, dragging the easel down with him. When Pauline ran to help him up, he cried:

"Leave me! Pick up the drawings first!"

She obeyed and gathered up a number of drawings that had fluttered off in every direction. Then, helping him to his feet, which was no easy task, she asked:

"What happened? Are you hurt?"

He gingerly felt his arms and legs and said, reassured:

"No, I haven't broken anything ... As I was getting up, I hadn't seen that my heel was caught on the easel and it tripped me over. Look, my girl, my nice clothes are covered in dust!"

"It's nothing, Monsieur Degas. We'll brush them out and the dust won't show at all ... But what bad luck for

the one time that you happen to be in your Sunday best!"

"And my drawings! Ah! now here's the one I was working on, ruined! I'll have to have it repaired at once; the man should come to fetch it this very morning. Assume the pose, my girl."

While the model posed she could no longer see Degas. He didn't seem to be doing much work and stopped frequently to sit down in his chair and rest.

"Eh, Pauline," he said, "I bet you're surprised to see me all dressed up and handsome. It's because I'm going to lunch at my friends', the Rouarts, and I can't just show up there in my old rags."

"What a nice lunch you're going to have, Monsieur Degas."

"I hope so. And what's more, I'll have the pleasure of spending a few hours with my old childhood friend. I'm very fond of him, except when he starts talking about awards. Even he has this mania for distinctions and decorations! ... But he knows me well, the old bugger! When I attended the luncheon his friends threw him on the occasion of his pink rosette, everyone had to make their little speech, and right before it was my turn he whispered in my ear: 'I'd rather you say nothing at all.' He didn't trust me, ha!"

"And you didn't say anything?" Pauline asked.

"No. He's a good man and one of the few close friends I have left; most of the rest died long ago ... And then there are others I can't visit any longer on account of their wives. They think I'm an old crank, just because I don't

like having a bouquet of flowers stuffed up my nose when I'm trying to eat."

"Ah! yes," the model said. "I remember you saying a few times you couldn't stand the scent of flowers."

"Perfume and flowers give me awful headaches," Degas confirmed. "And so I never anymore set foot in a house where the women insist on decking out their dining tables with bouquets when they're perfectly aware of my aversion ... There's only one scent I truly love: burnt bread. Do you like it too, Pauline?"[16]

"I wouldn't say I dislike it."

"Well, we're going to burn a little. In fact, I brought up a bit of bread for my drawings."

Two minutes later, Degas paced back and forth across the atelier, a trowel in his hand on which there was a smoking piece of bread he'd let half-carbonize in the fire.

"Doesn't that smell good?" he said to Pauline.

Still holding the trowel, from which there rose a thick black smoke, Degas stopped in front of an incomplete drawing and sighed:

"My Lord, if only I could finish it! But I'll never draw again, my sight gets worse and worse each day ... How awful it is not to be able to see clearly. What kind of life is this for a painter! God, don't let me go blind! I'd rather die ..."

Pauline pretended not to have heard his laments, and in a cheerful tone, said:

"Monsieur Degas, do you remember the first time I ever came to see you? Louise brought me here so you could see if I was shapely enough to pose."

"As a matter of fact, I do remember. I was the first man to see you nude. But it took some coaxing. You didn't want to take off your shirt; Louise almost had to tear it off of you by force. But I thought your prudishness was charming."

"Imagine it! Stripping down to nothing in front of a man!"

"Is an artist a man?" replied Degas with a shrug. "You were quite pretty, but you posed so poorly! Impossible to make you hollow out the small of your back!"

"You punched me right there over and over until I got it."

The old artist laughed:

"Little scoundrel! I should never have paid you to teach you to pose ... Come, we'll have to put away all these drawings I've left strewn about everywhere."

He kept only the pastel he'd been working on and put all the other drawings into boxes that he then carried into the room at the back of the atelier. He was in there a good quarter of an hour, moving canvases and frames and boxes, when a brisk ring of the bell interrupted him. Pauline saw him reenter the atelier alongside a strong, tall man, with a loud voice and an authoritarian air.

Degas led his visitor to the easel:

"Here is your pastel. But there's still something I want to add to it. If you could wait just a few minutes ... Pauline, give me the pose."

"Please, Monsieur Degas," the man protested. "Don't bother yourself about it. The dancer is perfect just like this; the line and coloring are marvelous. I'll take it as it is, if you'll allow me?"

He put the drawing into a box, and said:

"Aren't you lunching at the Rouarts', as usual? I've got a carriage waiting outside. I could take you there."

"I'd like that," the old artist replied. "There's no point now in trying to get down to work ... You can get yourself dressed, my girl."

While she dressed behind the screen, Pauline heard Degas tell the man the story of his fall from earlier. He added a little anecdote about Cézanne to his tale.[17]

One day Cézanne got his foot stuck in his easel and fell down onto the floor of his studio. But instead of recognizing the true cause of the accident, he swore that one of his enemies had set a trap in order to kill him. In his old age, Degas said, Cézanne lost any control over his persecution mania, which meant he could think only in conspiracies.

*

* *

The following morning, Pauline found Degas in the dining room in conversation with a man of about fifty, with dark black hair and a beard to match. They were talking politics, railing against "this miserable government." Degas concluded:

"Society can only exist so long as there are prejudices. The idea that all men are equal is blasphemy."

"Yes, an abomination," the visitor added, with a sidelong, contemptuous glance at the old maid, who, seated in her place next to the window and wearing her

typical camisole, listened in impassive silence to their conversation.

They spoke of their friends and were highly amused by a certain illness that a younger man of their mutual acquaintance was being treated for.

With a saucy glance at the model, the man said:

"Heh, well, they need to spread their seed, those young folk! We've all had it at one time or another and we haven't died of it yet."

In the atelier, Degas began by putting away the easels and benches that cluttered the front of the space. He drily refused Pauline's offer of help and dragged the heavy modeling platform to its usual position by himself. After a long examination of his statuette, he sat down in his chair, sighing deeply.

Pauline asked him to tell her about yesterday's famous lunch, and he reeled off the succession of dishes that had made up the meal.

"What a charming family!" he said. "All of them going to such trouble for me. Not like when I go to Forain's ...[18] The last time I accepted an invitation to dine with Forain, I asked them to move up the hour of the meal. They usually have their supper at nine in the evening, but that's simply too late for a man of my age. And so there I was at eight, and a maid served me my soup. I was alone at the table with one of their kids. Forain and his other guests didn't eat until nine ... I've never gone back ... Forain still calls me Mister Deh-gaz ..."

He was lost in thoughts that, to judge by the expression on his face, could hardly have been pleasant.

They finally got to work. But Degas barely looked up to it and dozed off during the long and frequent breaks.

When the session had finished, Pauline calculated that she had posed, all told, barely an hour.

The same thing happened again the following day, and the days after.

Always slumped in his chair, he only opened his mouth to complain about his poor eyesight and the bladder disorder that kept him from sleeping. He spoke in a low, cryptic voice about death as well, confessing the atrocious fear it inspired in him.

Deep down Pauline was truly fond of "Father Degas," in spite of his brusque manners and regressive ideas, and she was alarmed to see him in such a morbid mood. She spoke about it to Zoé, who reassured her:

"You know, miss, there are always these moments of crisis in monsieur's illness. But it's not serious, he'll recover as he has before. It's just that he's so delicate he thinks himself already dead."

But sure enough, a handful of days later, the old governess was waiting at the door of the third floor for the model to arrive. She explained to Pauline that monsieur had come down with a cold and was confined to his bed on the doctor's advice. In no condition to work, he asked that Pauline come see him in his bedroom.

Zoé led her down a hallway, then through two enormous salons, and finally into a room where a wood fire

blazed in the hearth. At first Pauline was dazzled by the fire's light dancing on the walls and floor, but she finally managed to make out the brass bars of the little bed in the rear of the room and, nestled among the white sheets and pillows, Degas's ashen face. He held out a hand to her and said, lugubriously:

"Ah! my girl, now I am truly ill. I'm going to die, I can feel it."

Pauline tried to assume a disinterested tone:

"But remember, Monsieur Degas, that you already told me that, in those same words, six years ago, and you recovered. You were even more strapping than before. It'll work out the same way this time, too."

"But this time I'm six years older!" Degas replied. "Ah! no, I'll never see my atelier again."

"Don't talk like that! The artists I tell all your little adventures to, what would they think?"

"Shush," Degas said with a smile, "we certainly can't go about spreading stories like those in front of Zoé. What would she say about her master? Come back tomorrow, perhaps I'll have gotten better by then. Zoé will pay you…"

As she left, Pauline would have liked to stop awhile in the two salons where she could see a number of large canvases on easels or hung on the wall. But she had to keep the pace of the old governess, who walked as quickly as she could, in a rush to get back to the kitchen.

It was only once she was in the hallway that she got a quick look at a large painting that she'd noticed a few times before, a very odd version of Manet's *Olympia*.[19]

Still lightly feverish, Degas stayed in bed throughout the following days. Each morning, Zoé would lead the model to his bedside and she would spend a dozen or so minutes trying to lift the mood of the sick old man. As she shared the latest art world gossip, her eyes darted around the bedroom, trying to get an idea of it; but thanks to the half darkness in which the room was plunged, the curtains being barely open, she could only make out the vague shapes of a few pieces of furniture and the gleam of frames that surrounded the numerous tableaux hung to the wall.

They finally came to the last morning she had reserved for Degas, without him ever recovering enough to return to work.

The old artist decided to ask Pauline not to come back until eight days later, so as to avoid continuing to pay for sessions he could make no use of. But when the model arrived on the day in question, she was surprised to find Degas still bedridden.

He told her that one day when he couldn't wait any longer to get back to his atelier, he'd gone up for a single hour and had caught yet another cold there, in the glacial room.

More morose than ever, he said:

"Ah, my dear! I'm saddened by the thought that I can't work with you! Go, leave me now; it pains my heart to see you here. I'll write to you as soon as I've recovered."

With work in full swing, as it always was in January, Pauline had no trouble rebooking the mornings she'd

saved for Degas with other artists. She patiently waited for a letter asking her to come back and pose again, but weeks went by without a word from him.

One day she learned from Juliette that he'd long since recovered and that he now worked with Juliette and Yvonne.

"Go and see him," her friend advised her. "You know how much he hates to write."

The following day, Pauline went to the rue Victor Massé toward one in the afternoon. Degas, finishing his lunch with a cup of tea and a cigarette, received her warmly. But when she asked him if she should reserve any more sessions for him, he became awkward:

"I'd like to work with you again, my dear, to finish that poor statuette I've been poking at for such a long time now. But I don't have any sessions free. I've already booked Juliette and Yvonne ... Come again in two or so weeks and we'll see."

Twice the artist sent her away again, asking that she return a few weeks later; but the third time he welcomed her coldly. Pauline could feel that the sight of her was disagreeable to him, since it reminded him of the unfinished statuette and he wanted above all to put it firmly out of mind. He dismissed her on the spot, with words that she felt were unkind:

"We have nothing left to do together."

His words made Pauline bitter, and she stopped passing by his apartment. But Juliette, who posed for him almost every morning, told her that he sometimes asked

after her and was surprised that she never dropped in to say hello anymore.

When she finally went back to see him, he received her in a charming fashion but made no mention of wanting to get back to work on the statuette eventually. Pauline didn't mention it either, and contented herself with telling him some amusing stories about the follies of other artists in their endless quests for medals and ribbons.

She kept dropping by once in a while, but his mood was always so changeable: he would sometimes greet her as an old friend, received with pleasure, and sometimes as an importunate pest to be hurried out the door. After a final welcome even colder than the others, Pauline gave up on her visits entirely.

A year later, she heard from a friend that Degas had moved to the Boulevard de Clichy,[20] because the house on rue Victor Massé where he'd had three floors for almost a quarter of a century was going to be demolished and replaced with a modern building.

The young girl was curious to see Degas's new home and, one day, she climbed the stairs to the sixth floor and rang the bell.

Zoé received her with a delighted gasp and, leading her into a rather dark room, cried out:

"Monsieur, it's Miss Pauline."

Degas lifted his head from his plate and asked, curtly:

"What do you want from me, Pauline?"

"Nothing, Monsieur Degas. I just wanted to come see how you were doing. Are you well?"

"Yes. Zoé, serve my tea. Good day, Pauline."

"Good day, Monsieur Degas."

That was the last time she ever saw the old artist.

1 Zoé Closier. "For more than a quarter of a century, she cared for the artist with tireless solicitude. Zoé was more than a domestic servant; she was Degas's governess." Paul Lafond, *Degas*, 2 vols. (Paris: H. Floury, 1918–1919), p. 98. She had replaced her predecessor, Sabine Neyt, in the middle of the 1880s. [Translator's note: Notes to the text are from the 2012 French edition published by L'Échoppe.]

2 Degas had moved there in April 1890 from a building nearby, at 21, rue Pigalle. "'Three stories: sleep on the third, eat on the fourth, work on the fifth,' as the concierge explained to us. On the third was Degas's private museum; on the fourth his old sketches and drawings; on the fifth, the atelier." Daniel Halévy, *Degas parle* (Paris and Geneva: La Palatine, 1960), p. 120. Until 1887, rue Victor Massé was named rue de Laval. From 1866 to 1874, Degas was listed in the voting registry as living on the rue de Laval.

3 Nationalist, anti-Semitic newspaper founded in 1892 in Paris by Édouard Drumont (1844–1917), ex-art critic; it exposed the Panama scandal. The newspaper's subtitle was "France for the French."

4 Henri Rouart (1833–1912), classmate of Degas at Lycée Louis-le-Grand, engineer and industrialist, amateur painter and collector. He lived on the rue de Lisbonne.

5 Nothing is known of Degas's romantic life, which remains a mystery.

6 Plastiline is a heat-sensitive modeling clay made of kaolin, sulfur, and grease, invented in the nineteenth century.

7 Degas had been for many years a diligent follower of the opera.

8 In 1904, this "pleasure establishment" opened across from Degas's home at 36, rue Victor Massé. It closed in 1953 and was razed and replaced by a supermarket in 1966.

9 Degas and the painter Pierre Puvis de Chavannes (1824–1898) admired each other's work. The pair were witnesses to the marriages of the two daughters of their common dealer, Paul Durand-Ruel: Marie-Thérèse in May of 1893, and Jeanne Marie Aimée in September of that same year.

10 Henri-Joseph Harpignies (1819–1916), landscape painter and watercolorist, given the nickname "Michelangelo of trees and peaceful fields" by Anatole France. Fifteen years older than Degas, he was to die only a year before him.

11 Degas made his last trip to visit the Neapolitan branch of his family in November of 1906.

12 Degas traveled in Italy from 1857 to 1858 and met there Gustave Moreau (1826–1898), who was a considerable influence on him.

13 Degas traveled to the United States to visit his family in New Orleans from October 1872 to March 1873.

14 Paul-Albert Bartholomé (1848–1928), painter and sculptor, friend of Degas and Puvis de Chavannes.

15 Rue de Douai is in the extension of the rue Victor Massé. Ludovic Halévy lived at number 22.

16 Degas writing to Vollard about a dinner invitation: "No flowers on the table, and make sure it's at precisely 7:30 ... And if there are women, can you see that they don't come perfumed? ... All of these awful odors! ... And when you think that there are some things that smell so good, like toasted bread ... And even a light whiff of shit." Ambroise Vollard, *Degas (1834–1917)* (Paris: G. Crès et Cie, 1924), pp. 3–4.

17 In spite of their conflicting characters and temperaments, Degas owned seven paintings by Cézanne, almost all of them acquired in the middle of the 1890s. For more on Degas's personal collection, see Ann Dumas et al., *The Private Collection of Edgar Degas* (New York: The Metropolitan Museum of Art, 1997).

18 Jean-Louis Forain (1852–1931), painter and illustrator. A friend of Degas, he participated in the first Impressionist exhibitions. In the first years of the 1890s, he became a devout Catholic and anti-Semite.

19 This must have been the version painted by Gauguin in 1891 (now in a private collection), bought by Degas in 1895 in the course of the public sale organized by the artist before what was to be his last voyage in Polynesia. Degas had purchased a number of works by Gauguin, beginning in 1881.

20 At 6, Boulevard de Clichy, next to the eighteenth arrondissement, almost at the intersection of that road with the rue des Martyrs, in a six-floor apartment without an elevator. It was Suzanne Valadon who found him the apartment in 1912.

ALICE MICHEL is the pseudonym used by the unknown author of *Degas and His Model*.

JEFF NAGY is a translator, critic, and historian of technology based in Palo Alto, California. His research focuses on networks pre- and post-Internet and the development of digital labor.

"Ekphrasis" is traditionally defined as the literary representation of a work of visual art. One of the oldest forms of writing, its meaning originated in ancient Greece, where it referred to the practice and skill of describing people, objects, and experiences through vivid, highly detailed accounts. Today, ekphrasis is more openly interpreted as one art form, whether it be writing, visual art, music, or film, being used to define and describe another art form, in order to bring to the audience the experiential and visceral impact of the subject.

By bringing back into print important but overlooked books—often pieces by established artists and authors—and by commissioning emerging writers, philosophers, and artists to write freely on visual culture, David Zwirner Books aims to encourage a richer conversation between the worlds of literary and visual art. With an emphasis on writing that isn't academic in the traditional sense, but compelling as prose, and more concerned with subject matter than historical reference, *ekphrasis* invites a broader and more varied audience to participate in discussions about the arts. Particularly now, as visual art becomes an increasingly important cultural touchstone, creating a series that encourages us to make meaning of what we see has become more compelling than ever. Books in the *ekphrasis* series remind us, with refreshing energy, why so many people have dedicated their lives to art.

Degas and His Model
Alice Michel

Translated from the French
Degas et son modèle

Published by
David Zwirner Books
529 West 20th Street, 2nd Floor
New York, New York 10011
+ 1 212 727 2070
davidzwirnerbooks.com

Editor: Lucas Zwirner
Translator: Jeff Nagy
Project Assistant: Molly Stein
Proofreaders: Anna Drozda,
Clare Fentress

Design: Michael Dyer / Remake
Production Manager: Jules Thomson
Printing: VeronaLibri, Verona

Typeface: Arnhem
Paper: Holmen Book Cream,
80 gsm

Publication © 2017
David Zwirner Books

"A Model's Agency" © 2017 Jeff Nagy
Translation © 2017 Jeff Nagy

Special thanks to L'Échoppe for
permission to reprint the introduc-
tory note by Patrice Cotensin from
its 2012 French edition

Distributed in the United States
and Canada by
ARTBOOK | D.A.P.
75 Broad Street, Suite 630
New York, New York 10004
artbook.com

Distributed outside the
United States and Canada by
Thames & Hudson, Ltd.
181A High Holborn
London WC1V 7QX
thamesandhudson.com

ISBN 978-1-941701-55-3
LCCN 2017937789

David Zwirner Books

ekphrasis